HEROIC PAINTING

FEBRUARY 3 – APRIL 21, 1996

SECCA

SOUTHEASTERN CENTER FOR CONTEMPORARY ART

Sara Lee Corporation is the corporate sponsor for this exhibition

ACKNOWLEDGMENTS

A number of people helped me understand the evolving notion of the hero that is explored in "Heroic Painting." They work in diverse fields from social services to the arts, but all in some way interface with the heroic acts of daily life. I am grateful to Gayle Dorman, Suzi Gablik, Connie Grey, Nan Holbrook, Basil Talbott, and Emily Wilson for their input.

Thanks are also due to Ruth Beesch, director of the Weatherspoon Art Gallery, for helping me in my search for women artists. SECCA's staff worked diligently on many aspects of the exhibition.

Douglas Bohr, installations manager/registrar, and Karin Lusk, executive administrative assistant, coordinated the research and administration of the installation and catalogue. Their contribution far exceeded the parameters of their jobs. I would also like to acknowledge Jeff Fleming, curator; Angelia Debnam, programs administrative assistant; and Mel White, programs assistant.

Finally, I am indebted to the artists for providing insights on their work and to the lenders for their generosity.

— S.L.

This publication accompanies the exhibition

"HEROIC PAINTING"

February 3 – April 21, 1996

at the Southeastern Center for Contemporary Art, Winston-Salem, North Carolina.

SECCA is supported by The Arts Council of Winston-Salem and Forsyth County, and the North Carolina Arts Council, a state agency.

Published by the
Southeastern Center for Contemporary Art,
750 Marguerite Drive,
Winston-Salem, North Carolina 27106

Library of Congress Catalog Card Number: 95-73238

ISBN: 0-9611560-9-0

EXHIBITION TOUR:

Tampa Museum of Art, Tampa, Florida
May 5 – June 30, 1996

Queens Museum of Art, New York
July 19 – September 8, 1996

Knoxville Museum of Art, Knoxville, Tennessee
October 11, 1996 – January 12, 1997

The Contemporary Arts Center,
Cincinnati, Ohio
January 25 – March 23, 1997

Mississippi Museum of Art,
Jackson, Mississippi
July 19 – September 27, 1997

University Gallery
University of Massachusetts at Amherst
October 22 – December 14, 1997

Catalog design: Abby Goldstein

Editor: Nancy H. Margolis

Printing: Herlin Press

Photo credits: pp. 14, 15, courtesy P.P.O.W., New York; pp.16, 17, courtesy Littlejohn Contemporary, New York; p. 24, D. James Dee, courtesy Ronald Feldman Fine Arts, New York; p.25, courtesy Komar and Melamid; p. 26, courtesy Chase Manhattan Bank, NA, New York; p. 27, courtesy Walker Art Center, Minneapolis.

DEDICATION

"Heroic Painting" is dedicated to the memory of James Gordon Hanes, Jr. (1916–95). Head of the Hanes family of Winston-Salem, Gordon Hanes was a successful industrialist and businessman—the president and chief executive of the Hanes Corporation.

But Gordon Hanes may be best remembered as a private citizen who contributed his time and resources to nurturing his state and local community and to enhancing our nation's cultural life. Devoted to the arts and the environment, he served nationally on the Collector's Committee of the National Gallery of Art, the National Committee of the Whitney Museum of American Art, The Smithsonian Associates, and the World WildLife Fund. Within his home state, Gordon Hanes served two terms in the North Carolina State Legislature, and served as a director of the Board of Science and Technology, the Business Council of the Arts and Humanities, the Commission on the Status of Women, the Governor's Cultural Advisory Council, the North Carolina Nature Conservancy, the Winston-Salem State University Board, the North Carolina School of the Performing Arts, and the North Carolina Museum of Art, which he helped to found.

In 1977 Gordon Hanes spearheaded the decision to provide SECCA with a permanent home on his family's estate. Throughout SECCA's 40 years, Hanes was an avid supporter and adviser. He cared about artists and made great efforts to connect the artist and the community. For all his philanthropic deeds, recognized and unrecognized, we gratefully acknowledge Gordon Hanes as a traditional American hero.

HEROIC PAINTING

Susan Lubowsky, Executive Director

The twentieth century has witnessed the gradual dissolution of the mythic national hero. As the hero has descended into antihero and finally into caricature, elitist themes — "the great events of history in which individuals necessarily figure prominently" — have been replaced with a "history from below" in which ordinary people are the prominent figures. In the twentieth Jefferson Lecture in the Humanities, traditionalist historian Gertrude Himmelfarb traces the course of the decline of heroism and decries the loss of the hero to society. The "new history," she charges, has eliminated "those last remnants of heroism by denying not only the idea of eminence, but the very idea of individuality."[1]

The polarities that concern Himmelfarb — historic canon versus "new history"; high culture versus low culture — lead her to conclude that the traditional concept of the hero has been destroyed by contemporary scholars. She might have extended the blame to the news media, who regularly reduce the credibility of public figures, and to critics, who undermine the hero and, in so doing, assume the role themselves. In light of the recent "culture wars" raging about such issues as NEA funding, however, a more interesting point is how Himmelfarb's thesis of the hero's decline relates to the role of the artist as hero.

In his *Heroes and Hero-Worship*, Thomas Carlyle provides the standard description of the Victorian hero: The hero serves "as god, as prophet, as priest, as king, as poet, as man of letters." Although Carlyle does not include "artist" on his list, artists not only fit, but personify the Victorian ideal. But the Victorian ideal did not survive very far into the twentieth century. In fact, the very unconventional behavior and eccentricities decried by the Victorians as unheroic became the distinguishing traits of the new artist bohemian so admired by the modernists. Modernism "exalted the complete autonomy of art, and the gesture of severing bonds with society. This sovereign specialness and apartness was symbolized by the romantic exile of the artist, and was lived out in modes of rebellion, withdrawal, and antagonism."[2] As Flaubert commented: "Life is so horrible that one can only bear it by avoiding it. And that can be done by living in the world of art."

As the concept of heroism became increasingly muddled, the artist was there to digest, conceptualize, and reveal with painful astuteness the ambiguities that hover on the edge of our beliefs. Thus, the hero and antihero merged into one dramatic persona: the figure of the artist.

The treatment of heroic themes in twentieth-century art is part of a long tradition. Dramatic, grand-scale history painting came of age in the sixteenth century, when it was considered the apex of artistic pursuit. Leading the viewer to high moral ground by depicting the heroic acts of mythical and religious figures, history painting was instructional — its heroes and their ideals were models for the common man. By the nineteenth century, however, history painting seemed antiquated. The forefathers of modernism took the "academic history-painting model to task by punning visually upon the predictability of the compositions."[3]

Seen as a hackneyed academic genre, the tradition of history painting was not revived until the early modernist movement turned the genre to

its own ends. Employing irony and realism, early modernists, including Gustave Courbet, Theodore Géricault, and Edouard Manet, worked in the style of history painting, but twisted heroic themes into personal ones. Courbet's *Interior of My Studio, A Real Allegory Summing Up Seven Years of My Life as an Artist* (1854–55) is an example of grand-scale painting in which the artist substitutes his contemporaries for the mythic figures that a traditional history painting might have featured.

The contemporary artists shown in "Heroic Painting" continue the traditions of their early modernist forebears. Although they depict their "heroes" in the grand manner of earlier centuries, they tinge their narratives with irony. The legends, wars, cinematic landscapes, and larger-than-life personalities they depict are a means of presenting a polemic on the very concept of heroism at the end of the twentieth century.

The group of artists exhibited in "Heroic Painting" all work from the "history from below" perspective, dressing down and replacing heroes like John James Audubon, George Washington, and Frank Lloyd Wright with the native American, the slave, the common soldier, and the disabled child. But the artists distinguish themselves by their varied styles and their varied views of the hero and the heroic. Influenced by nineteenth-century artists, including Courbet and Géricault, and by a range of painters throughout history, Julie Heffernan, Vincent Desiderio, Bo Bartlett, and Walton Ford have an approach that is essentially serious. Lawrence Gipe, Vitaly Komar and Alex Melamid, and Mark Tansey, on the other hand, stress the irony of their messages, coupling the decidedly nonmodernist styles of social realism and socialist realism with modernist humor and a touch of cynicism.

Traditional historians like Gertrude Himmelfarb decry the replacement of the traditional historic canon with a "history from below," which replaces the mythic heroic figure with ordinary people. Complicit in the destruction of the heroic ideal are aspects of feminism and what has been labeled political correctness. In assembling this exhibition, however, I had great difficulty finding women artists whose subject and style fit the heroic theme. Suzi Gablik, who sympathizes with "history from below," attributed my dilemma to her belief that "heroism was the linchpin of patriarchy."

The one woman artist who emerged in my search is Julie Heffernan. Aesthetically grounded in traditional history painting, Heffernan nevertheless has a decidedly feminist viewpoint. In the style of the Old Masters, she paints idyllic landscapes and verdant pastures, but she places herself within these settings, using the self-portrait to examine archetypal womanhood and its attendant baggage.

Self-Portrait as Infanta Maria Teresa Playing Coriolanus (1995) is the most disquieting of Heffernan's allegorical works. It centers on an archaic Roman hero and a seventeenth-century Spanish infanta—and on Heffernan, who positions herself as their medium. As legend goes, the statesman Coriolanus aspired to become a senator. After a victorious battle, he came home and found

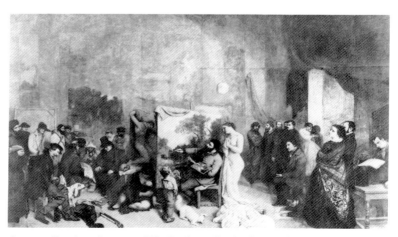

Gustave Courbet, *Interior of My Studio, a Real Allegory Summing Up Seven Years of My Life as an Artist*, 1854-1855

the mob demanding to see his scars. He demurred because such a display struck him as unseemly and would make him vulnerable to the rabble. His hesitation branded him forever as the symbol of snobbery.

Alluding to that story, Heffernan portrays herself as the princess made famous by Diego Velázquez, standing amidst a bovine herd — an unwashed mass. Like Coriolanus, she is wounded, her scar veiled in a bandage. But the scar Heffernan has placed on the infanta's womb is Heffernan's own scar, the remnant of an ectopic pregnancy. Heffernan saw that life-threatening experience as joining her to "the maelstrom of female history."

Also key to that history, Heffernan believes, is "a society that creates the deformed female in the name of beauty." In the seventeenth century, Velázquez immortalized the Infanta Maria Teresa as a feminine ideal, painting her restricted in corset and bedecked in jewels. Heffernan disrobes her subject, discarding the royal vestments that Velázquez painted so beautifully. Heffernan's contemporary infanta wears her wound as a badge of endurance and her hairpiece as a relic of her culture. Stripped of clothes, the contemporary infanta is no longer idealized. Her nakedness has little in common with the titillating bareness of Manet's *Olympia* (1863) or the creamy perfection of Jean-Auguste Dominique Ingres' *Odalisque* (1814). Like her modernist predecessors, Heffernan has infused the mythic with the personal in a scenario "where heroism comes down to street level."

When Heffernan and I discussed her concept of valor, she used the example of her three-year-old son. His reaction to her hospitalization and to his own recent hospitalization for a minor illness seemed to Heffernan to exemplify the heroic ideal. With great courage, he offered himself up to a battery of painful tests.

Like Heffernan, Vincent Desiderio has personal experience with the heroism of a child. His eight-year-old son, Sammy, struggles with a birth defect that has at times been life-threatening, and he requires constant medical care. *Study for a Hero's Life* (1992) shows Sammy in a hospital bed, his lifeline a snaky green tube. The canvas is small, but its impact is heroic.

Desiderio is an aesthetic descendent of Velázquez, of Velázquez' admirer Manet, and of Manet's contemporaries, Delacroix and Géricault. Vast triptychs dominate Desiderio's oeuvre, powerfully resonating the most violent and mythic aspects of history painting. He describes himself as a painter who "jumped the modernist ship. . . into hypermode, a post-structuralist mode."[4] His stories emerge through layers of meaning-coded messages referencing a whole history of art and literature. "They are darkened mirrors," he says. "You see the past and the present."

Desiderio's triptych *The Progress of Self Love* (1990) is heavy with allegory and operatic in scope. Moving freely between world events and personal despair, Desiderio juxtaposes private tragedy in the left panel with the public devastation of war in the center, and adds a mysterious underwater scene on the right. Since 1990, when the work was completed, it has been the subject of a number of analytical critiques. The art critic and historian Sam Hunter considers it a morality tale in which each panel illustrates the sins of ambition and narcissism.[5]

In the first panel, Desiderio's studio has become the scene of a murder. A naked model, a policeman, and the deranged and strait-jacketed artist and perpetrator are stars in a theater of mystery and hidden meanings. Never revealing the plot, Desiderio does leave clues. The neo-geo painting dominating the back wall of the studio represents art of the 1980s, a period of easy money and art-world narcissism. The murder might well be the result of that narcissism run amok.

The center panel is a theater of war — of heroic acts played out on a beachhead, but bearing an uncanny resemblance to a portrayal of hell in the

Renaissance. Soldiers have taken the cavernous trench in the foreground but are being shot down as they try to overtake the beach.

The third and most enigmatic panel extends from the beachhead to a cutaway of an ocean. In this theater of dreams, Desiderio metaphorically plunges to the depths of the primal unconscious, the archetypal unknown. The presiding figure is Ahab, overlooking the grave of his tormentor, the whale. But the conclusion of Herman Melville's story has been altered: Ahab, rather than joining Moby Dick at the bottom of the sea, "wanders haplessly in search of his other half." In this panel, as in so much of his work, Desiderio uses the grand myths that shape a nation's history as ways to explore his own psyche and to comment on the polemics of modernism and its contemporary manifestations. The final panel shatters the dualities that Desiderio has set up throughout the triptypch — artist and model, warrior and victim, Ahab and whale, and finally hero and antihero. "My attitude toward the heroic," he says, "is not necessarily intact."

Like Desiderio, Bo Bartlett infuses national symbols with personal iconography. In the best tradition of history painting, Bartlett isolates the moments that define an era. His subjects, like the hunter portrayed in *Lamm Gottes* (1989), are everymen. Their kinship is with the depression-era heroes in American scene painting who manifested the ideals of democracy. But Bartlett's images are disturbing; his settings dreamlike. Inspired by divergent heroes — painters Norman Rockwell and Andrew Wyeth from his childhood, and psychologist Karl Jung and theologian Thomas Merton from adulthood, Bartlett plumbs the depths of the American psyche.

In 1993 Bartlett began a trilogy of monumental paintings on war. *Hiroshima*, the first and still unfinished work, depicts the moment before nuclear impact. For Bartlett, "holding history still before the blast — before that one point when everything irrevocably changed — is almost like not letting it happen." *Civil War*, begun in 1994 and only recently completed (Bartlett continually reworks the paintings in his studio) is rooted in real time and space. It is based on the Battle of Nashville, the turning point of the war, which gave General William T. Sherman the opportunity to move his troops down to Georgia.

Civil War was a way for Bartlett, a displaced Southerner facing mid-life, "to find the meaning of home." The Battle of Nashville was the first in this country to be fought in the snow, and Bartlett depicts the bleak desolation of its aftermath. In the distance, a Confederate wife struggles to save her husband, as many women did on the battlefields of the South. The real action, though, occurs in the foreground, at the painting's central axis, where a bare-shouldered woman holds a dying Union soldier who was once a slave. The pose recalls Michelangelo's *Pieta* (1498-1500) — the compassion of Mary and the martyrdom of Christ. In the dead of winter, steam rises from the woman's body, forming a small halo above her head. The religion of Bartlett's Georgia childhood still plays an important role in his life, contributing to the deeply felt mystical implications of his work.

When first conceived, *Homeland* (1994) was to be titled *Returning to St. Lô*, as a tribute to the Normandy town destroyed during World War II. *Homeland* is a liberation scene in which the villagers, not aware that their tragedy will continue, go home. "They are moving through space and time," Bartlett explains, "moving toward something, but we're not sure what." Like *Civil War*, *Homeland* is as much about a sense of place and belonging as it is about a specific war. The central figure, a girl in a yellow dress, embodies hope and promise. Bartlett clearly acknowledges his debt to the great painters of history and allegory — to Courbet, whose *Interior of my Studio* inspired compositional passages, and to Géricault and Delacroix, whose respective paintings *Raft of the*

Medusa (1818–19) and *Liberty Leading the People* (1830), inspired the girl in *Homeland* and the woman in *Civil War*. For Bartlett, the true heroes are survivors rather than victors.

Walton Ford's heroic themes also resound with the tragedies of American history, from the settlement of the West to plantation life in the South. In the primordial wilderness, Indians and homesteaders enact their struggles; on the plantations, masters hold tight to the reins of slavery. Painted in the stiffly narrative style and sepia tones of American primitive canvases, Ford's work looks deceptively authentic. But the veneer of age disguises a postmodern interpretation of the myths of our national past. Ford espouses a revisionist history—one that edifies the victim and debunks the hero.

In 1990 Ford began a series of paintings exploring the myth of John James Audubon. Audubon's wilderness expeditions and the art he produced place him securely within the pantheon of American heroes. Today, Audubon so symbolizes the environmental movement that the Audubon Society even bears his name. But Audubon's journals present a more ruthless picture. *John James Audubon — The Head Full of Symmetry and Beauty* (1991) graphically depicts the carnage of a buffalo hunt described in Audubon's 1843 Missouri River journal. Riding on a flatboat, Audubon, his back to the viewer, sketches the head of a decapitated buffalo. Spotlit by the setting sun, the artist is unmoved by the slaughter around him, focusing only on the "symmetry and beauty" of his art. In portraying Audubon as antihero, Ford comments on the elite position artists assume in the name of a higher calling.

Journals can be powerful tools for the "new history." Certainly Audubon's journals, read over 150 years after they were written, seem brutal to modern sensibilities. An equally shocking source are the journals of slave holders. Ford's ancestors held slaves on their Nashville, Tennessee plantation, and his great-grandmother's diary, *The Autobiography of Emily Donelson Walton: 1837– 1936*, was published, Ford says, partly as a justification to show that the Waltons were good masters. But at least two of the entries challenge that intention, and they have become a springboard for Ford's work: "Among the little babies born on the plantation was one having six fingers on each hand. My mother cut off the extra fingers and I buried them under the rose bush in her flower garden. She was given to me and I named her Queen Victoria. I once saw a picture of the baby Queen with pigeons around her, and I thought it a beautiful name for my little pickaninny." Another entry tells of Uncle Guinea George, a slave from New Guinea who posed as a cannibal to frighten his owners. He gained some degree of control over his destiny by baring his sharp teeth (a New Guinea cosmetic enhancement) and saying, "We do it because we eat people."

"Using personal sources," Ford says, "absolves me of the accusation that I am pointing fingers at other people. This is me. . . . I would have owned slaves and we would be at war with the Indians." The skeletons Ford found in his family

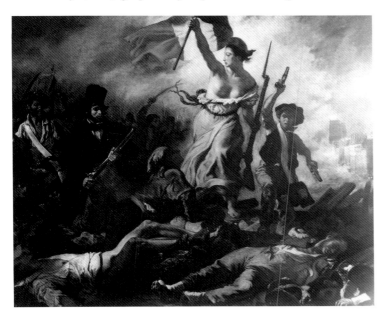

Eugène Delacroix, *Liberty Leading the People*, 1830.

closet implicate him, and the lesson he learned relates to heroism: "It is stupid to have heroes in the first place. History is too often written by people who want to keep their heroes clean, flat, one-sided."[3] Power shifts, heroes fall, and history rewrites itself.

Ford's equestrian paintings take these issues head-on. Mimicking historical works that show the gentry in mastery and control of a spirited animal, they use the equestrian image as an allegory for political control. *A Faulty Seat* (1992), for example, resounds with the fear induced by Guinea George. Something has spooked the master's horse, and the situation could explode as the slaves are called upon to reign in the beast. It could be Ford's great-grandfather in the saddle, struggling to maintain the power structure of the antebellum South. Ford's relatives, he imagines, would have collected prints by the equestrian painter Stubbs and by Audubon. "That imagery is my legacy. I attack that imagery from within."

The artists discussed so far share a decidedly serious approach to their art and to the subject of the hero. The remaining artists have a lighter touch, stressing irony, modernist humor, and a touch of cynicism.

Vitaly Komar and Alex Melamid created their blueprint for the modern antihero during the early 1970s. As Soviet dissidents, they cannot be pigeonholed in the academic debate between old and new history, being neither leftwing nor pro-heroic. Reacting to their native culture, which has dismantled its heroes with each new regime, Komar and Melamid portray those national heroes with humor, irony, and a degree of nostalgia.

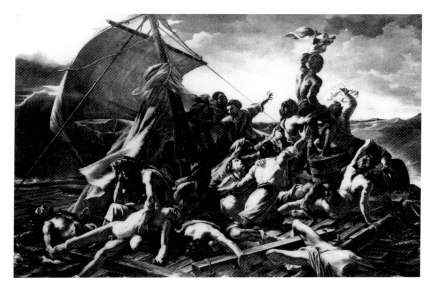

Théodore Gèricault, *The Raft of the Medusa*, 1819

Komar and Melamid's initial inspiration was the heroic depiction of Lenin and Stalin that was so prominent during their childhoods. In 1972 Komar and Melamid were commissioned to decorate a children's camp with likenesses of Soviet heroes. The camp director took them to the spot where a bust of Stalin had been buried years before, and Komar and Melamid were struck with the idea that all over Russia similar statues lurked underground. This dislodged early memories of public spaces filled with Stalin's image. "[But] suddenly one day," Melamid recalled, "he was gone — everything associated with Stalin was bad. In the summer in the camp with the buried Stalin, we suddenly realized that Stalin art isn't good art, it's not bad art, it's just art. This was a great discovery for us. . . . There were no taboos anymore."[7]

In *Double Self-Portrait* (1973), Komar and Melamid substituted their own profiles for those of Lenin and Stalin. Komar and Melamid's attempts to exhibit such work — work that mocked Moscow's worship-or-destroy ideology — led to their expulsion from the Moscow Union of Artists in 1974 on charges of "distortion of Soviet Reality and deviation from the principles of Soviet Realism."[8] Komar and Melamid could not adhere to the allegiance to a collective political purpose that was demanded of all official Soviet artists. In 1977 they

emigrated, first to Israel and a year later to the United States, where they live and work today.

Trained in the realist style favored by the Communist regime, Komar and Melamid mimic history painting. "Our training in art was pre-revolutionary. Sometimes after you get to a certain level of oil painting, you make a certain brushstroke and realize it's a painterly gesture from the nineteenth century. Maybe the system is preserving a gesture by Delacroix, who knows? In Russia, it's preserved forever." In an interview after their arrival in New York, they explained: "Art in the Soviet Union is divided into two parts — form and content. All official works are based on that principle. In a Moscow gallery, you can see Lenin in Courbet style, Lenin in Cézanne style — that's good form and good content." For Komar and Melamid, good form and bad content were far more engaging.[9]

In a series of over two dozen social realist paintings executed between 1980 and 1984, Komar and Melamid recount memories of the Stalinist regime. "The real Stalin time was about life, death, blood," Melamid says. "It was a terrible time but a deep one, a real one."[10] It was also a time when art served the purpose of the totalitarian regime. *I Saw Stalin Once When I Was A Child* (1981–82) alludes to the nostalgia and the fear Stalin evoked. Close examination also reveals Stalin's resemblance to Melamid, whose snapshot served as a model. This ploy diminishes the impact of Stalin's bearing, casting him as a figure who is comic and somewhat pathetic.

As a counterpoint to the socialist realist series, Komar and Melamid created another group of works they call Ancestral Portraits. Taking on the stance of state leaders, dinosaurs pose before velvet curtains or appear spotlit, as in *Bolsheviks Returning Home after a Demonstration* (1981–82). The paintings are allegorical; the dinosaurs relics of an ancient and extinct history.

After a period of ambitious projects and installations, Komar and Melamid recently returned to painting in the social realist style, but they now focus their attention on American democracy. In a project conceived for *Artforum* magazine, Komar and Melamid announced: "It's time to take the next step — to create new and original versions of American social realism. At the end of the century and the millennium, the year 1999 will mark the 200th anniversary of George Washington's death. But revolutionaries never die! We call on everyone who believes that the revolutionary legacy of the Founding Fathers is threatened with extinction to create work devoted to this patriotic theme." With the fervor of a political broadside, Komar and Melamid's project invited "cultural workers" to "sign up for the Five-Year Plan 1994–99."[11] As an inspiration to other artists, they offer their painting, *Washington Lives II* (1994). To drive home their slogan, "Revolutionaries never die!", they have outfitted Washington in a business suit as though ready to lead a new form of revolution.

Like Komar and Melamid, Lawrence Gipe is motivated by the myths surrounding complex heroes and their fall from grace. In large-scale paintings and painting installations, he evokes the grandiosity of history painting, but he never actually shows a hero. Instead, he offers symbolic portraits, the icons of the machine age — skyscrapers, industrial plants, planes, and locomotives.

Gipe's method is to appropriate artistic genres of the first half of this century, but turn them to his own ends. Evocations of social realism, with its strong ideological thrust, and precisionism, the American modernist movement that heralded industrialization and the apotheosis of the machine, lend a veneer of authenticity to Gipe's revisionist history. In fact, the symbolic portrait was itself an invention of modernism, introduced in the early 1900s by the French Dadaists and adopted by the American modernists.

Gipe's *The Century of Progress Museum* (1992) is a painting installation about the corruption of power and industrialization. The title refers to the

1933 Chicago World's Fair, held during the Great Depression, but called the Century of Progress. With the instincts of today's spin doctors, the crafters of the fair marketed their creation on the nation's hope for an optimistic future. Gipe portrays Robert Moses, Teddy Roosevelt, Henry Luce, and the German arms manufacturer Alfred Krupp as the dubious heroes of a capitalist era: "They were men who started out as idealists in an industrial age," Gipe says, "but they became obsessed with power — unaccountable power — and the results were often tragic."

Triptych No. 1, from *The Century of Progress Museum*, continues Gipe's Krupp Project, begun in 1990. In his notes for the project, Gipe speaks of his fascination with the Krupps, the Essen family dynasty that for almost 400 years dominated German production of steel and armaments. The Krupp firm was the mythic embodiment of Germany's modern industrial state; the very name evoked a sense of nationalism. "The Krupps were heroic in a way that no Carnegie or Rockefeller could hope to be," Gipe says. "They were a patriarchal head in the fatherland."

True capitalists, the Krupps served Germany's reigning leadership, from the kaisers to the Nazis. Their fortune was amassed through centuries of successful political alignments. The family slogan "Necessity Knows No Law" became their driving force during World War II. In a Faustian bargain with Hitler, Krupp manned its factories with over 100,000 slaves, recruited from the Buchenwald concentration camp. When these workers became debilitated, they were returned to the camp to die. The phrase used to describe Essen to newly arrived foreign workers — "Hier wohnt stille des herzens" or "Here dwells the heart's repose" — is emblazoned across the bottom of Gipe's triptych.

The Nuremberg Tribunal sentenced Alfried Krupp to only ten years' imprisonment. United States intervention further reduced the sentence to thirty months, since Krupp steel was needed to rebuild the nation, which would be a useful ally against the Soviet bloc. Within a decade, Krupp was among the richest and most powerful men in Europe. For Gipe, this bellwether of the new Germany was the quintessential antihero.

Throughout the Krupp Project, Gipe presents a romanticized, almost spiritual view of Krupp's steel mills. The dramatic effects of sunlight and smoke recall the precisionist vision of the industrial plant as the modern cathedral. But unlike the precisionists, Gipe is insincere in his romanticism; he uses it in an ironic way to reveal false heroes. "My highly aestheticized portrayal," Gipe says, "while in many senses critical, also inevitably reinforces the masculine, mythmaking agenda of large-scale painting."

Mark Tansey is more interested in the act of transformation of the hero than in the result. "Is the loss of the hero just the loss of a simplistic notion of the truth?" he asks. To address this confounding question, Tansey chooses representation as his artistic mode. The massive schemas he constructs use the conventions of history painting and have the look of works created during the first decades of this century. His canvases also allude to early photography, with their monochrome palette in hues that range from sepia to bluish-black.

The illusion of age, so common to the works in "Heroic Painting," is critical to Tansey's dialectic. But Tansey's "history paintings" don't deal with actual history. Through layers of images sometimes interspersed with text, Tansey presents "hybrid histories" — ironic situations that could never actually occur. Thus, Tansey adamantly distances himself from the realists: "In contrast to the assertation of one reality, my work investigates how different realities interact and abrade."[12] If one sees a history painting when viewing works like *Purity Test*, *Homage to Frank Lloyd Wright*, or *Constructing the Grand Canyon*, Tansey asks what one expects of that history painting. "Within my pictures, any level of content might seem jarring and might break up the unity of a history painting. So the painting is not absolutely a history painting."

11

This is clearly the case in *Purity Test* (1982). Here, Tansey conjures two incongruous moments in time, as Indian braves look down from a cliff over the Great Salt Lake. What holds their gaze is Robert Smithson's seminal earthwork of 1970, *Spiral Jetty*. The Indians are romanticized, depicted as noble savages. As Arthur Danto points out, *Purity Test* imitates the style of Frederic Remington: "Neither Remington's nor Tansey's appropriated style would have had a place in the art world in which *Spiral Jetty* was admired as an achievement. The art world of the late 1960s and early '70s was one of aesthetic renunciation and austerity, marked by the quest for the pure essence of art, and hence a reduction of art to its most primitive components."[13] In *Purity Test* Tansey poses this question: Would Smithson, the hero of late modernism, measure up to the standards of the true primitive hero? Would he pass the purity test?

In *Homage to Frank Lloyd Wright* (1984), Tansey takes on the great American hero of modern architecture. One of Wright's last and most controversial projects was the Guggenheim Museum in New York, criticized by many as a monument to Wright himself rather than an environment for the display of artworks. As Tansey puts it: "Wright ignored all the circumstances that are ideal for showing art. His building is an example of architecture defeating art." Tansey's painting "returns that arrogant gesture." Again using the style of history painting, in particular the romanticized portrayals of the great sea battles of the Civil War, Tansey metamorphosizes the Guggenheim Museum into a battleship, perhaps the Monitor or the Merrimack. In fact, the Civil War ironclads were transformations of innocent paddlewheelers. Tansey's transformation of the Guggenheim, like the transformation of the paddlewheeler, results in an "unbelievable monstrosity."

The ideals of romanticism also figure strongly in Tansey's *Constructing the Grand Canyon* (1990). Mimicking the conventions of romanticism developed by nineteenth-century romantic painters of the American West like Alfred Bierstadt and Frederik Church, Tansey manifests his own grand vision. *Constructing the Grand Canyon* reflects on how romantic conventions have been challenged by deconstruction, the philosophic movement that emerged during the 1960s. Deconstruction posits that texts have no absolute meaning — that all text is open to interpretation. Tansey explains: "The deconstructionists' primary method treats everything as text. Nature too becomes a textual construct."

In Tansey's painting, the Grand Canyon is being unearthed from text, and the archaeologists of this ambitious scheme are the very architects of deconstruction: Michael Foucoult teeters on a boulder at the left, and the Yale School — Paul DeMan, Jacques Derrida, Harold Bloom, and Geoffrey Hartman — work at the painting's center. Humorously, Tansey depicts these postmodern heroes in business suits or their classroom garb. The workers, muscular young men and women, are dressed in the clothes common to both construction workers and students. "Their goal in the painting," Tansey says, "is to deconstruct romanticism and to rebuild it from the texts of their own ideology. What follows is really a kind of pseudo-non-heroism."

The evolving twentieth-century definition of the hero does not necessarily mean that the hero no longer exists. Rather, it may mean that the proper defining characteristic of heroism is the ability to adapt to a milieu. The artists in "Heroic Painting" use the stylistic conventions of their progenitors to question old values and to search for new ones. As postmodernists, they cast doubt on the credibility of their forefather's heroes. As contemporary artists, they struggle to maintain their integrity in a culture that has cast them in an adversarial role.

As the millennium closes, it is questionable whether artists will continue to play the antihero. *New York Times* columnist Anthony Lewis has praised the Chinese dissident Wei Jing Sheng, who was jailed for organizing non-conformist painting exhibitions: "In a cynical time," he writes, "we Americans long for heroes."[14]

The cycle set in motion with the advent of modernism has come full circle. Flaubert's belief that you can avoid life by immersing yourself in art no longer seems admirable. Today, the isolation of the artist has become a crisis that polarizes our nation's cultural life. Perhaps artists in the next century will claim their place as agents of enlightenment — as the heroes we long for.

NOTES

Unless otherwise noted, all quotations come from conversations with the artists in December 1995 and January 1996.

1. Gertrude Himmelfarb, "Of Heroes, Villains, and Valets," 20th Jefferson Lecture in the Humanities, presented under the auspices of the National Endowment for the Humanities, Washington, D.C., 1 May 1991. Himmelfarb also quoted Carlyle, as cited in the next paragraph.

2. Suzi Gablik, "Changing Paradigms, Breaking the Cultural Trance," *The Reenchantment of Art* (New York: Thames and Hudson, Inc., 1991), p. 5. Gablik also quotes Flaubert.

3. Thomas Sokolowski, *Morality Tales: History Painting in the 1980s* (New York: Independent Curators Incorporated, 1987), p. 8.

4. Quoted in Ellen Pall, "Painting Life Into Sammy," *The New York Times Magazine*, 29 January 1995, p. 37.

5. Sam Hunter, *Vincent Desiderio: Recent Paintings* (exhibition catalogue) (New York: Marlborough Gallery, 1993).

6. Quotations in this paragraph are from an interview with Walton Ford in the exhibition catalogue *History 101: The Re-Search for Family* (St. Louis: Forum for Contemporary Art, 1994), pp. 19–20.

7. Quoted in Carter Radcliff, *Komar and Melamid* (New York: Abbeville Press, 1988), p. 17.

8. Radcliff, *Komar and Melamid*, p. 59.

9. Quotes in this paragraph are in Radcliff, *Komar and Melamid*, pp. 27 and 79.

10. Quoted in Radcliff, *Komar and Melamid*, p. 30.

11. From Project Page, "Komar and Melamid's 'The People's Choice'," *Artforum International*, January 1995, p. 75.

12. Quoted in Arthur C. Danto, *Mark Tansey: Visions and Revisions* (New York: Harry N. Abrams, Inc., 1992), p. 132.

13. Danto, *Mark Tansey: Visions and Revisions*, p. 19.

14. Anthony Lewis, *New York Times*, 15 December 1995.

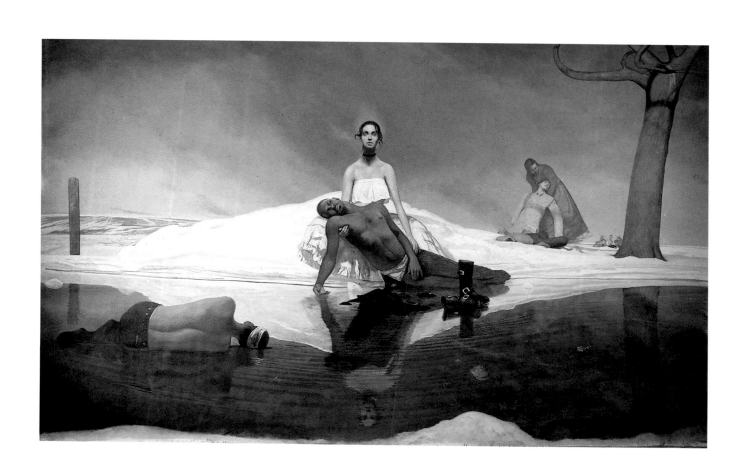

14 **BO BARTLETT** *Civil War*, 1994-1995

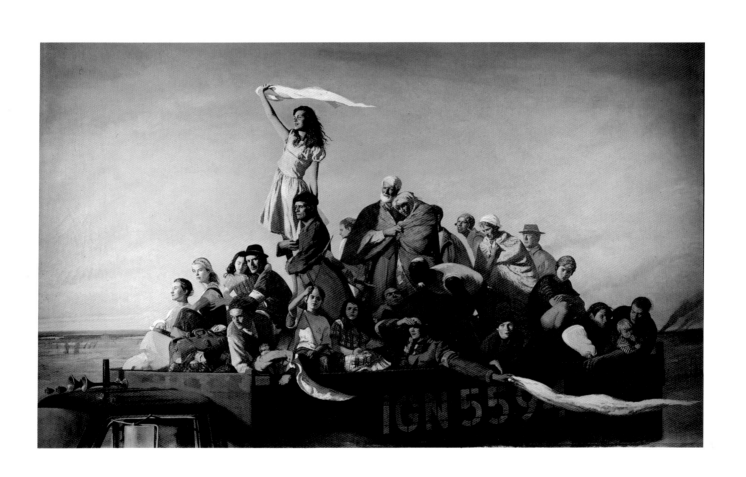

BO BARTLETT *Homeland*, 1994 15

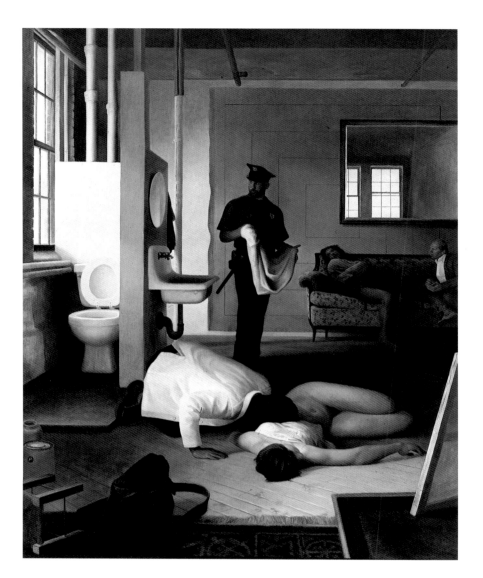

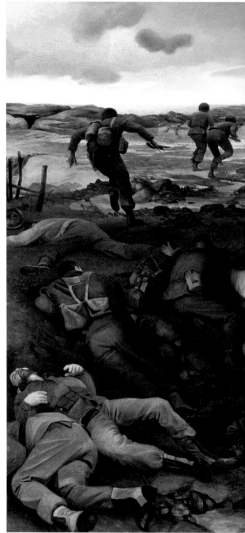

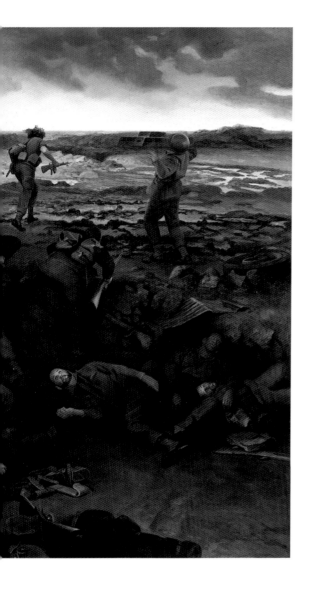
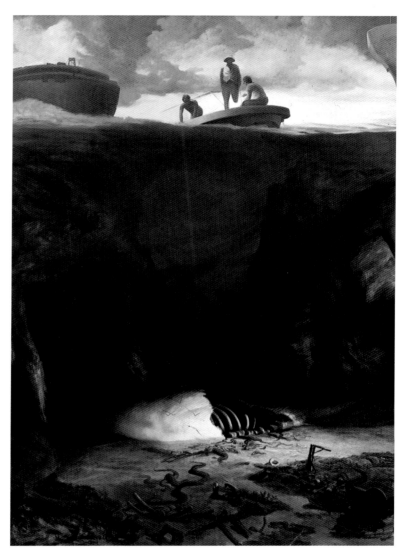

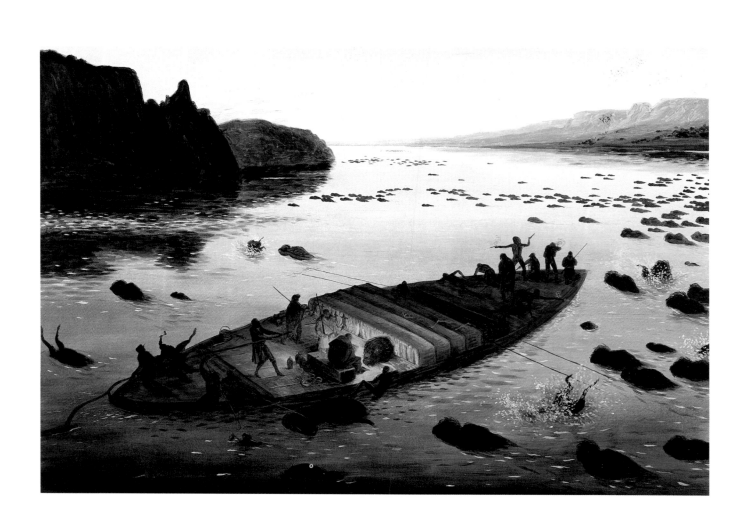

WALTON FORD *John James Audubon–The Head Full of Symmetry and Beauty*, 1991

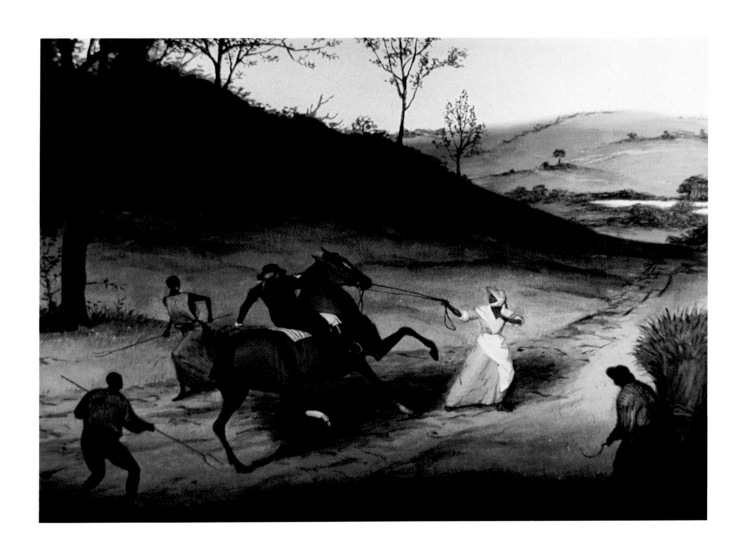

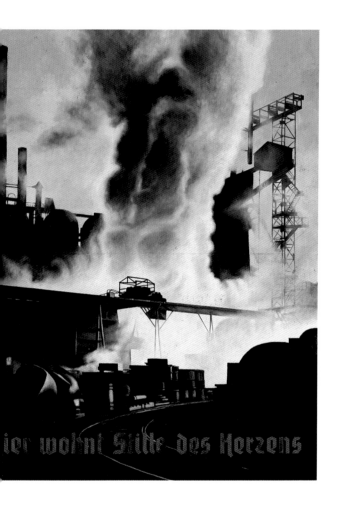

ier wohnt Stille des Herzens

22 **JULIE HEFFERNAN** *Battle Zone*, 1991

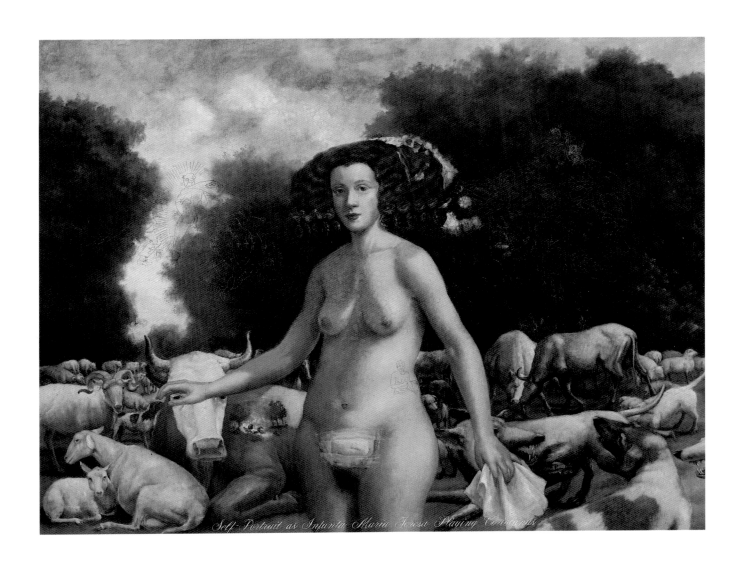

JULIE HEFFERNAN *Self-Portrait as Infanta Maria Teresa Playing Coriolanus*, 1995 23

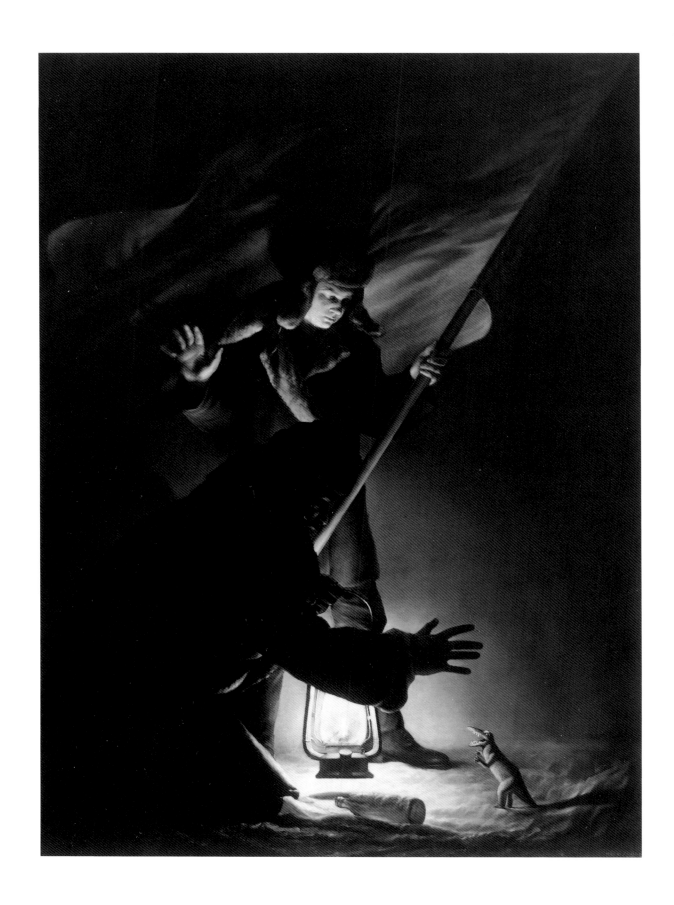

24 **KOMAR AND MELAMID** *Bolsheviks Returning Home After a Demonstration, 1981-82*

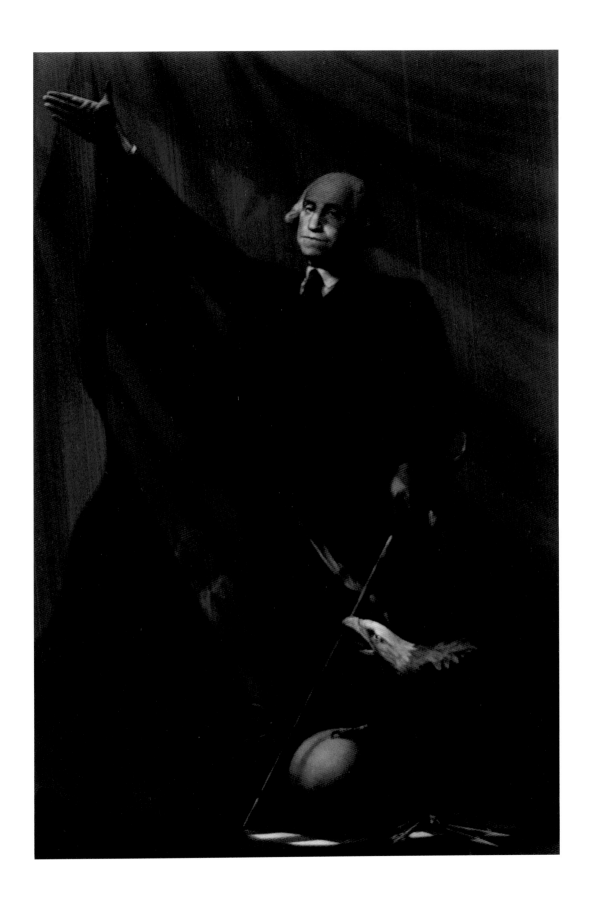

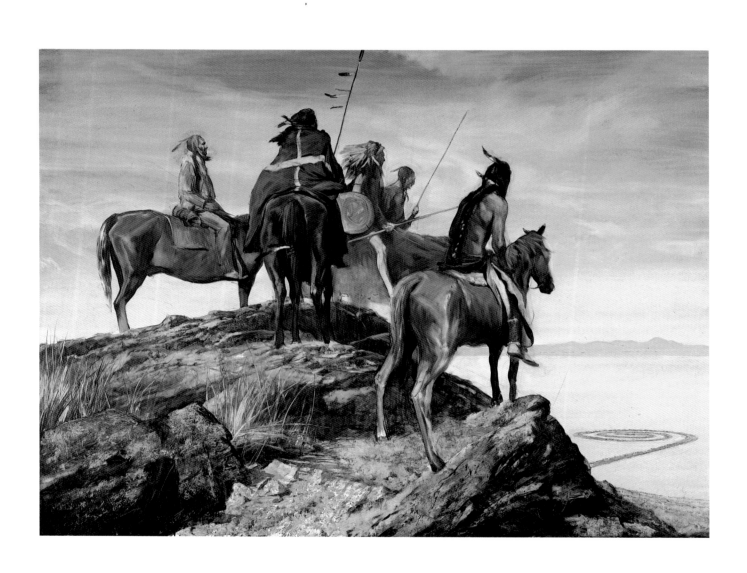

26 **MARK TANSEY** *Purity Test*, 1982

CHECKLIST

1. **BO BARTLETT**
Lamm Gottes, 1989
Oil on birch panel with gold-leaf frame
18 x 11 inches
Collection of Adam Reich
Courtesy of P.P.O.W., New York

2. **BO BARTLETT**
Homeland, 1994
Oil on linen
134 x 204 inches
Courtesy of the artist and P.P.O.W., New York

3. **BO BARTLETT**
Civil War, 1994 −1995
Oil on linen
134 x 204 inches
Courtesy of the artist and P.P.O.W., New York

4. **VINCENT DESIDERIO**
The Progress of Self Love, 1990
Oil on canvas
Triptych
111½ x 341¾ inches overall
Left panel: 108 x 87¼ inches
Center panel: 108 x 119½ inches
Right panel: 108 x 87¼ inches
Courtesy of the artist and Marlborough Gallery,
Inc., New York

5. **VINCENT DESIDERIO**
Study for a Hero's Life, 1992
Oil on canvas
19⅞ x 32⅛ inches
Courtesy of the artist and Marlborough Gallery,
Inc., New York

6. **WALTON FORD**
*John James Audubon−The Head Full of
Symmetry and Beauty*, 1991
Oil on linen
64¾ x 93¾ inches
Collection of Helen Alexander, Lexington,
Kentucky

7. **WALTON FORD**
The Homestretch, 1991
Oil on wood
47¾ x 64¾ inches
Collection of Anthony Scotto, New York

8. **WALTON FORD**
A Faulty Seat, 1992
Oil on wood
38 x 48¾ inches
Collection of Margot Frankel, New York

9. **LAWRENCE GIPE**
Triptych No. 1 from the Century of Progress Museum, 1992
From "The Krupp Project"
Oil on panel
114 x 268 inches
Courtesy of the artist and Helman Gallery, New York

10. **JULIE HEFFERNAN**
Battle Zone, 1991
Oil on canvas
68 x 90½ inches
Courtesy of the artist and Littlejohn Contemporary, New York

11. **JULIE HEFFERNAN**
Self-Portrait as Infanta Maria Teresa Playing Coriolanus, 1995
Oil on canvas
47¾ x 61¾ inches
Courtesy of the artist and Littlejohn Contemporary, New York

12. **KOMAR AND MELAMID**
Bolsheviks Returning Home after a Demonstration, 1981–82
From the "Nostalgic Socialist Realism" series
Oil on canvas
72 x 55 inches
Collection of Robert and Maryse Boxer, London, England
Courtesy of Ronald Feldman Fine Art, New York

13. **KOMAR AND MELAMID**
Washington Lives II, 1994
Oil on canvas
72 x 48 inches
Courtesy of the artists, New York

14. **MARK TANSEY**
Purity Test, 1982
Oil on canvas
72 x 96 inches
Collection of the Chase Manhattan Bank, NA, Art Program, New York

15. **MARK TANSEY**
Homage to Frank Lloyd Wright, 1984
Oil on canvas
32 x 85 inches
Collection of the Carnegie Museum of Art, Pittsburgh, Pennsylvania

16. **MARK TANSEY**
Constructing the Grand Canyon, 1990
Oil on canvas
85 x 126½ inches
Collection of the Walker Art Center, Minneapolis, Minnesota
Gift of Penny and Mike Winton, 1990

ARTIST BIOGRAPHIES

BO BARTLETT

Born 1955, Columbus, Georgia

Lives in Bala Cynwyd, Pennsylvania

EDUCATION

1975- Pennsylvania Academy of Fine Arts, Philadelphia
1981

1977- Philadelphia College of Osteopathic Medicine,
1978 Anatomy Studies

SELECT SOLO EXHIBITIONS

1988 "Sublimism: New Paintings and Drawings,"
 The Cast Iron Building, Philadelphia
 P.P.O.W., New York

1990 Greenville County Museum of Art, Greenville,
 South Carolina

1991 P.P.O.W., New York

1992 Daniel Saxon Gallery, Los Angeles

1993 Moore Gallery, Philadelphia
 F.A.N. Gallery, Philadelphia

1994 P.P.O.W., New York

1995 John Berggruen Gallery, San Francisco
 Struve Gallery, Chicago

VINCENT DESIDERIO

Born 1955, Philadelphia, Pennsylvania

Lives in Tarrytown, New York

EDUCATION

1977 B.A. Fine Art/Art History, Haverford College,
 Haverford, Pennsylvania

1977- Academia di Belle Arti, Florence, Italy
1978

1983 Four-Year Certificate, Pennsylvania Academy of
 Fine Arts, Philadelphia

SELECT AWARDS

1987 Pollock-Krasner Foundation Grant
 National Endowment for the Arts, Fellowship

SELECT SOLO EXHIBITIONS

1986 Lawrence Oliver Gallery, Philadelphia

1987 Lang and O'Hara Gallery, New York

1988 Greenville County Museum of Art, Greenville,
 South Carolina

1989 Lang and O'Hara Gallery, New York

1990 Lang and O'Hara Gallery, New York

1991 The Queens Museum, New York
 The Metropolitan State College of Denver, Center
 for the Visual Arts, Denver, Colorado

1993 Marlborough Gallery, New York

WALTON FORD

Born 1960, White Plains, New York

Lives in New York, New York

EDUCATION

1982 B.F.A., Rhode Island School of Design,
 Providence, Rhode Island

SELECT AWARDS

1988 The Penny McCall Foundation, Grant
 Art Matters, Inc., Fellowship

1989 New York Foundation for the Arts, Fellowship
 The Pollock-Krasner Foundation, Grant

1990 Mid-Atlantic Arts Foundation, Grant

1991 National Endowment for the Arts, Fellowship

1992 John Simon Guggenheim Memorial Foundation,
 Fellowship

SELECT SOLO EXHIBITIONS

1990 "The Blood Remembers," Bess Cutler Gallery, New York

1991 Bess Cutler Gallery, New York

Bess Cutler Gallery, Santa Monica, California

1993 "Procrustean Beds," Nicole Klagsbrun Gallery, New York, in collaboration with Michael Klein, Inc.

"Walton Ford," The Contemporary Arts Center, Cincinnati, Ohio

Virginia Beach Center for the Arts, Virginia Beach, Virginia

1993 "Selections from The Century of Progress Museum," Modernism Gallery, San Francisco

"The Robert Moses Project (Text and Subtext)," BlumHelman Gallery, New York

1994 "Selections from The Century of Progress Museum," Ruth Bloom Gallery, Santa Monica, California

"Lawrence Gipe," The Chrysler Museum, Norfolk, Virginia

"Montage Paintings," Modernism Gallery, San Francisco

1995 "Lawrence Gipe: Approved Images, New Paintings," BlumHelman Gallery, New York

LAWRENCE GIPE

Born in Baltimore, Maryland

Lives in Los Angeles, California, and New York, New York

EDUCATION

1984 B.F.A., Virginia Commonwealth University, Richmond, Virginia

1986 M.F.A., Otis Art Institute of Parsons School of Design, Los Angeles

SELECT AWARDS

1989 National Endowment for the Arts, Fellowship

SELECT SOLO EXHIBITIONS

1990 "The Krupp Project," Shea and Beker, New York

"Themes for a Fin de Siecle," Karl Bornstein Gallery, Santa Monica, California

1991 "Futurama," Shea and Bornstein Gallery, Santa Monica, California

1992 "Lawrence Gipe Monotypes," BlumHelman Gallery, New York

"The Propaganda Series," Galerie Six Friedrich, Munich, Germany

"Insights Exhibition: 'Lawrence Gipe: Century of Progress Museum,' " Worcester Art Museum, Worcester, Massachusetts

"Century of Progress Museum," BlumHelman Warehouse, New York

JULIE HEFFERNAN

Born in San Francisco, California

Lives in New York, New York

EDUCATION

1981 B.F.A., University of California at Santa Cruz, Santa Cruz, California

1985 M.F.A. in Painting, Yale School of Art, New Haven, Connecticut

SELECT AWARDS

1986 Fulbright-Hayes Grant to West Berlin
Annette Kade Grant for the Creative and Performing Arts

1987 Institute for Art and Urban Resources P.S.1., Artist in Residence and Studio Grant, Long Island, New York

1990 Skowegan School of Painting and Sculpture, Painting Fellowship

1993 Centre de Rechere et Mediation Valence, Art III, France

1994 Hillwood Art Museum, Project Residency Grant

1995 National Endowment for the Arts, Fellowship

Pennsylvania State University, College Faculty Research Grant

Pennsylvania State University, Institute Research Grant

1988 "Berlin–New York," Littlejohn Contemporary, New York

1989 "New Paintings," Littlejohn Contemporary, New York

1992 "Recent Work," Littlejohn Contemporary, New York

1993 "Paintings," Littlejohn Contemporary, New York

1994 "New Paintings," Littlejohn Contemporary, New York

1995 "New Paintings," Littlejohn Contemporary, New York

 Leedy Voulkos Gallery, Kansas City, Missouri

KOMAR AND MELAMID

Vitaly Komar, born September 11, 1943, Moscow

Alexander Melamid, born July 14, 1945, Moscow

Live in New York, New York. Have lived in the United States since 1978.

EDUCATION

1967 Both graduates, Stroganov Art Institute, Moscow, Russia

SELECT ACHIEVEMENTS AND AWARDS

1970s Initiated SOTS art movement (Soviet version of Western pop art)

1981 National Endowment for the Arts, Fellowship

SELECT DUO EXHIBITIONS

1976 Ronald Feldman Fine Art, New York (thirteen exhibitions since 1976)

1978 Wadsworth Atheneum, Hartford, Connecticut

1985 Fruitmarket Gallery, Edinburgh, Scotland

1985 Museum of Modern Art, Oxford, London

1986 Musee des Arts Decoratifs, Louvre, Paris, France

1988 NGBK, Berlin, Germany

1990 Brooklyn Museum, Brooklyn, New York

1994 Alternative Museum, New York

1995 Herbert Johnson Museum, Ithaca, New York

1995 Passage de Retz, Paris, France

MARK TANSEY

Born 1949, San Jose, California

Lives in New York, New York

EDUCATION

1974 Harvard Summer Session, Institute of Arts Administration, Cambridge, Massachusetts

1975- Graduate Studies: Painting, Hunter College,
1978 New York

SELECT SOLO EXHIBITIONS

1990 "Mark Tansey: Art and Source," Seattle Art Museum, Washington; Montreal Museum of Fine Art, Quebec, Canada; St. Louis Art Museum, Missouri; Walker Art Center, Minneapolis; List Visual Arts Center, MIT, Cambridge, Massachusetts; Modern Art Museum of Fort Worth, Texas

 Kunsthalle Museum, Basel, Switzerland

 Curt Marcus Gallery, New York

1992 Curt Marcus Gallery, New York

1993 "28 Pictures," Curt Marcus Gallery, New York

 "Mark Tansey,": Los Angeles County Museum of Art, California; Milwaukee Museum of Art, Wisconsin; Modern Art Museum of Fort Worth, Texas; Museum of Fine Arts, Boston; Montreal Museum of Fine Arts, Quebec, Canada

1995 "Borders," Galleri Faurschou, Copenhagen, Denmark